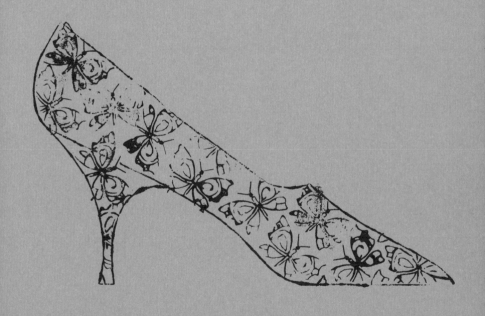

SHOES, SHOES, SHOES

SHOES, SHOES, SHOES

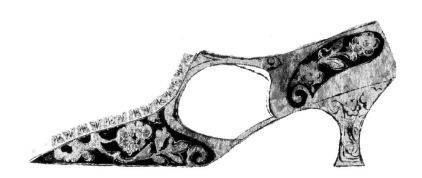

ANDY WARHOL

A BULFINCH PRESS BOOK

LITTLE, BROWN AND COMPANY BOSTON NEW YORK TORONTO LONDON

SECOND PRINTING, 1998
Quotations from Andy Warhol compiled by R. Seth Bright
Designed by John Kane

Library of Congress Cataloging-in-Publication Data

Warhol, Andy
 Shoes, shoes, shoes / Andy Warhol. — 1st ed.
 p. cm.
 "Quotations from Andy Warhol compiled by R. Seth Bright" — T.p.
verso
 ISBN 0-8212-2319-4 (hardcover)
 1. Warhol, Andy — Themes, motives. 2. Shoes in art. I. Bright, R.
Seth. II. Title.
NC139.W37A4 1996a
741.6'72'092 — dc20 96-13001

Bulfinch Press is an imprint and trademark of
Little, Brown and Company (Inc.)
Published simultaneously in Canada by
Little, Brown & Company (Canada) Limited

PRINTED IN SINGAPORE

Beauty is shoe, shoe beauty …

I **pop** right out of bed.

I shuffle,

I shuttle,

I tippy-toe,

I cakewalk.

You have to walk into that room

feeling popular.

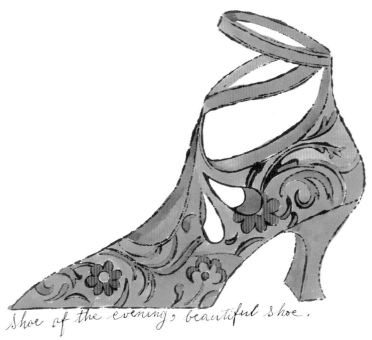

Shoe of the evening, beautiful shoe.

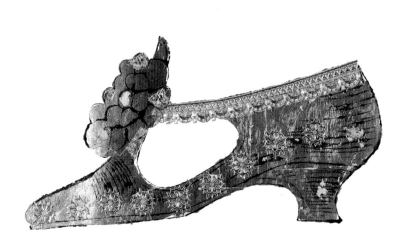

You

can impress a

whole roomful

of people

and with luck maybe you'll never see them again.

What would I do if

I were

President?

Oh,

I'd put carpets in the streets.

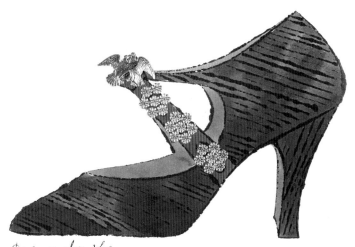

Dial M for shoe.

Andy Warhol

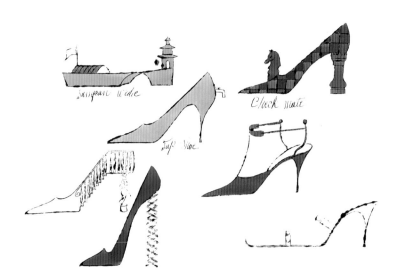

Sampan Wedge

Check Mate

Taps Shoe

A lot of good ideas

just seem to

fade

away.

If they told me to draw a shoe, a shoe,

I'd
do
it.

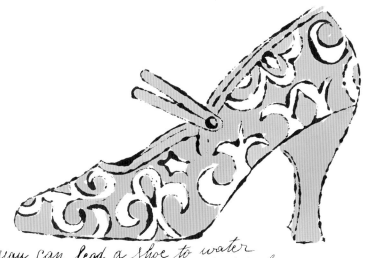

you can lead a shoe to water
but you can't make it drink.

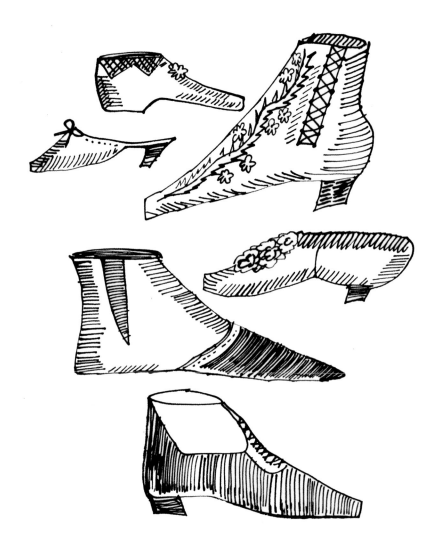

I never figured out
what they wanted.

But
they were willing to pay a lot
for it.

She only has the best,
the simplest
and the best.

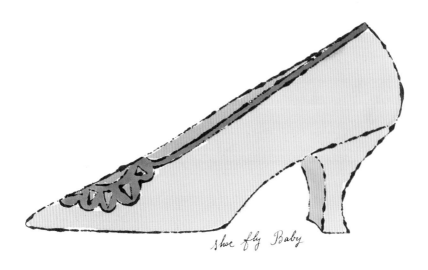

shoe fly Baby

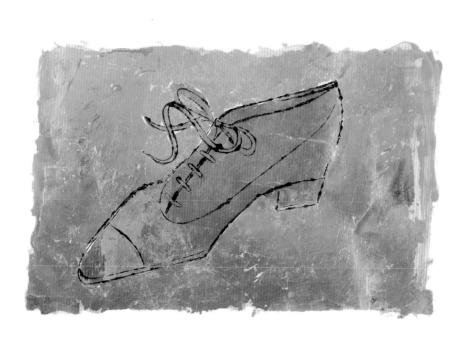

A good plain look is my favorite look.

Energy
helps you
fill up
more space.

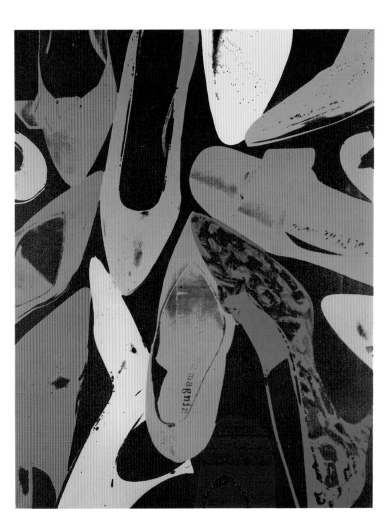

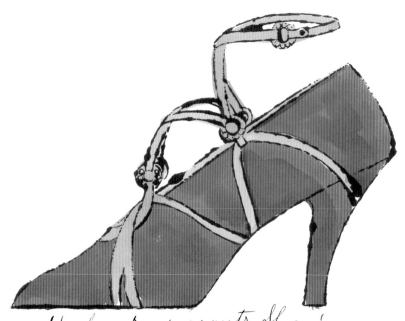

Uncle Sam wants Shoe;

She wears high heels **and** rides a bike.

Sometimes something beautiful different can look just because it's in some way from the other things around it.

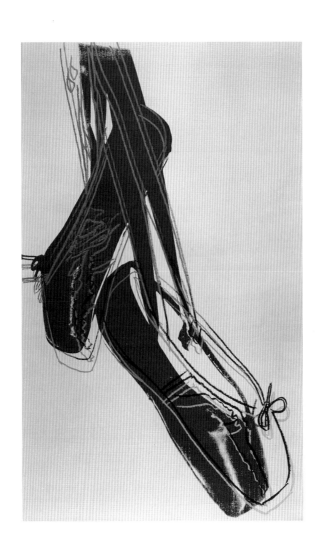

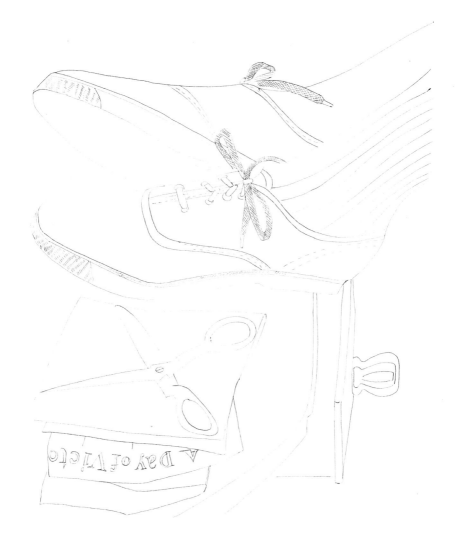

There are three things that always look very beautiful to me:

my same good pair of old shoes that don't hurt,

my own bedroom,

and U.S. Customs on the way back home.

She was a wonderful, beautiful blank.

The mystique to end all mystiques.

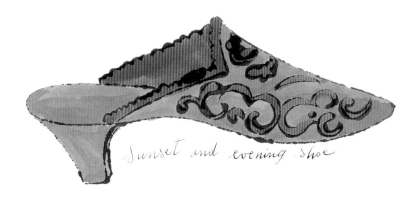

Sunset and evening shoe

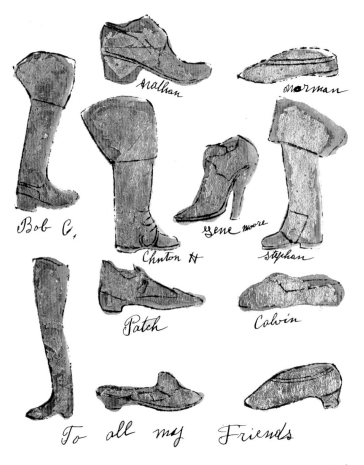

Nathan

Norman

Bob C.

Clinton H.

Gene Moore

Stephan

Patch

Calvin

To all my Friends

Andy Warhol

It was all great.
Jammed,
wall-to-wall people,
beautiful,

I don't know where they came from.

When you see
"beauty,"
it has to do
with the place,
with what they're wearing,
what they're standing next to,
what closet they're
coming down the stairs
from.

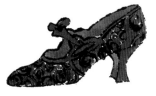

Beauty is shoe, shoe beauty ...

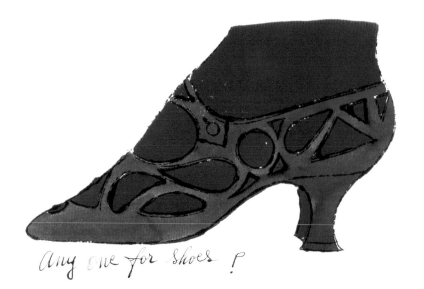

any one for shoes !

You can never predict what little things in the way somebody looks or talks or acts will set off peculiar emotional reactions in other people.

Her breeding still shows.

She can eat,
talk, and
walk
at the same time.

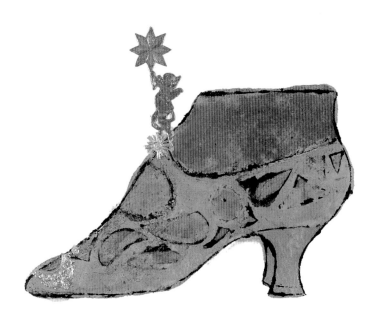

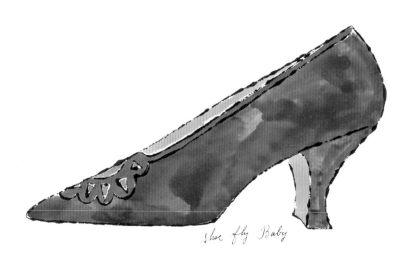

shoe fly Baby

A new idea.

A new look.

A new sex.

A new pair.

Everybody's sense of beauty is different from everybody else's.

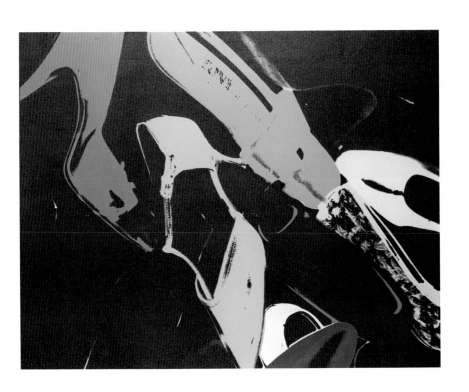

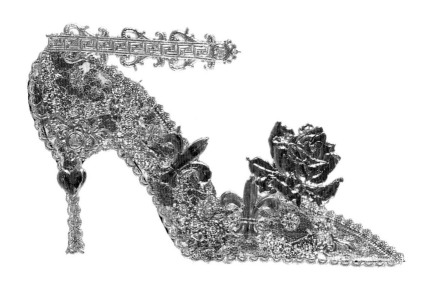

When I see people dressed in hideous clothes that look all wrong on them,

I try to imagine the moment
when they were buying them and thought,

"This is great.
I like it.
I'll take it."

It was so great
to have at least

someone there
to greet you,

and then just go away.

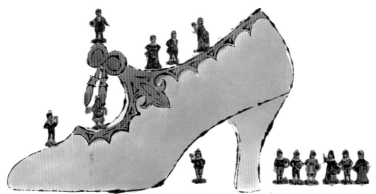

See a shoe and Pick it up and all day
long you'll have Good Luck

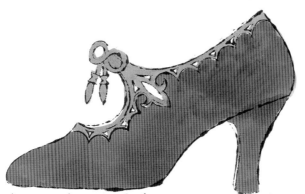

See a shoe and Pick it up and all day
long you'll have Good Luck

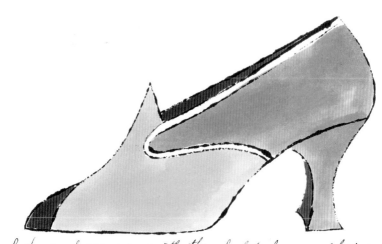

I dream of jeannie with the light brown shoes.

I decided that being
a shoe salesman
is really a
sexy
job.

So this means that
*if you see a well-dressed person today,
you know that they've thought a lot
about their clothes and how they look.*

And then that ruins it
because you shouldn't really
be thinking about how you
look so much.

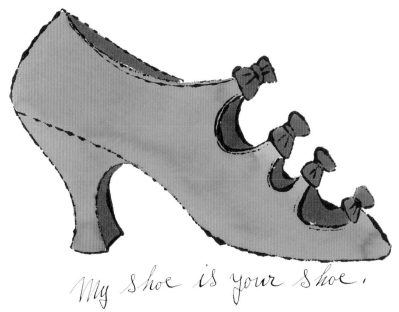

My shoe is your shoe.

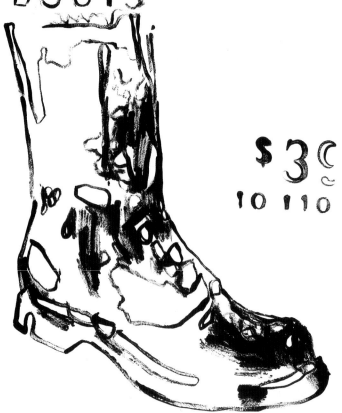

Maybe
I should stick
with

black.

How many pairs do you have here?

With everything changing so fast, you don't have a chance of finding your

fantasy image intact

by the time you're ready for it.

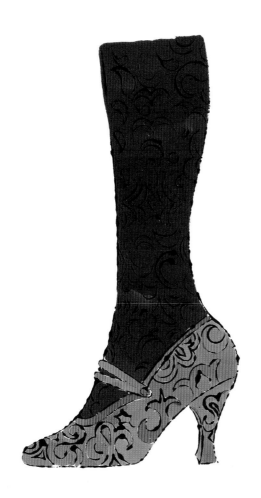

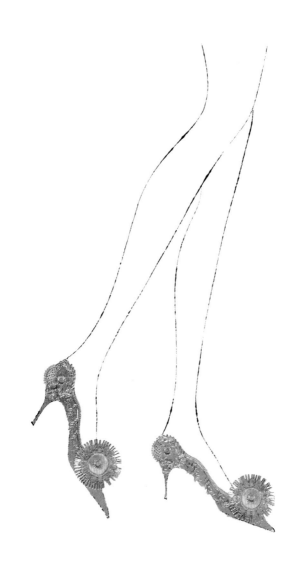

She had a... vulnerable quality that made her a reflection of everybody's private fantasies.

It's kind of refreshing to find a person who still blushes.

in her sweet little alice blue shoes—

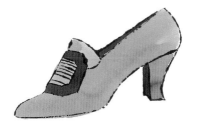

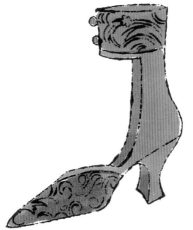

When I'm Calling Shoe.

The most plain or unfashionable person in the world can still be beautiful if they're very well-groomed.

I'm the type who'd be happy

not going
anywhere

as long as I was sure I knew
exactly what was happening
at the places I wasn't going to.

to shoe or not to shoe

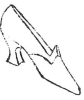

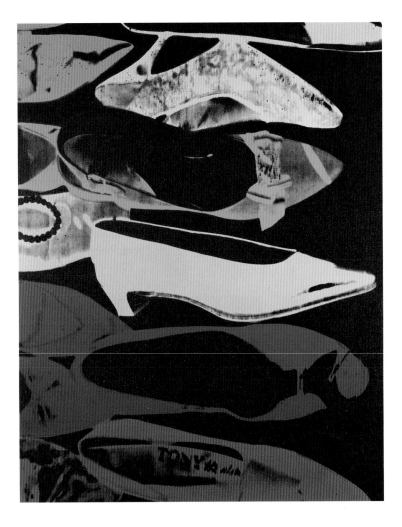

They can make themselves part of a **group** they might not otherwise be a part of.

They can't be bought

old,

they have to be bought

new.

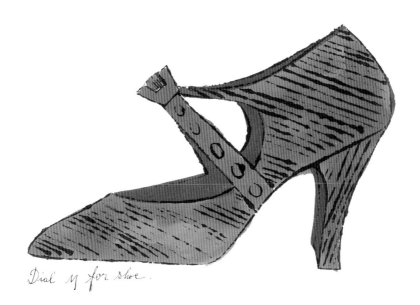

Dial M for shoe.

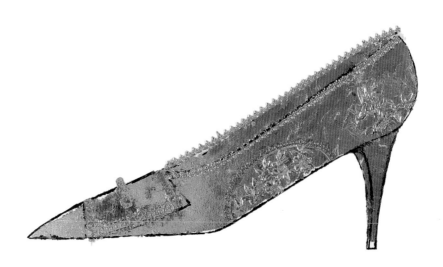

Whenever people and civilizations get degenerate and materialistic, they always point at their outward beauty and riches and say that if what they were doing was

bad,

they wouldn't be doing so well, being so rich and beautiful.

She had high heels on.

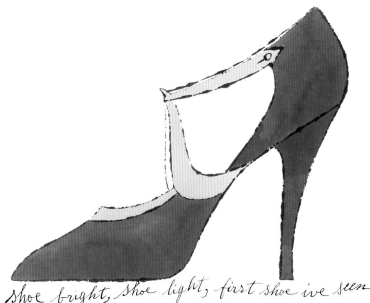

shoe bright, shoe light, first shoe i've seen
tonight

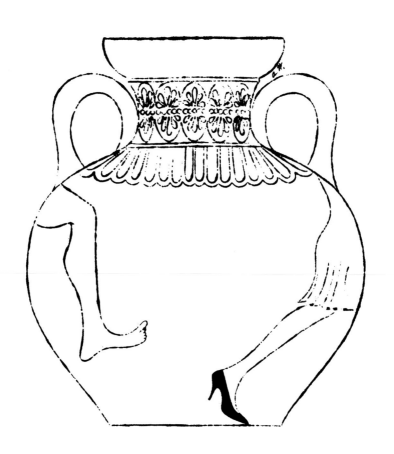

All quotations are by Andy Warhol
and were first published as follows:

Pages 7, 11, 19, 23, 24, 28, 31, 32, 36, 39, 40, 43, 44, 47, 52,
55, 56, 59, 63, 68, 71:
 Andy Warhol. *The Philosophy of Andy Warhol (from A to B
 and Back Again)*. New York: Harcourt Brace Jovanovich, 1975.

Pages 15, 64:
 Andy Warhol. *America*. New York: Harper & Row, 1985.

Pages 8, 60, 67:
 Andy Warhol and Pat Hackett. *Andy Warhol's Party Book*. New
 York: Crown Publishers, 1988.

Pages 20, 27, 35, 51, 72:
 Pat Hackett, Editor. *The Andy Warhol Diaries*. New York:
 Warner Books, 1989.

Pages 12, 16, 48:
 Mike Wren. *Andy Warhol in His Own Words*. London:
 Omnibus Press, 1991.

Captions by page number

Cover
The Autobiography of Alice B. Shoe (From the portfolio: A la Récherche du Shoe Perdu), 1955
Offset lithography, watercolor, and pen on paper
9 3/4" x 13 3/4"

Endpaper
Untitled (Shoe with Butterflies), c. 1956–58
Ink and tempera on paper
14 3/8" x 22 1/2"

3 *Untitled (High Heel)*, c. 1957
Gold leaf, ink, and stamped gold collage on paper
23" x 29"

5 *Beauty Is Shoe, Shoe Beauty (From the portfolio: A la Récherche du Shoe Perdu)*, 1955
Offset lithography, watercolor, and ink on paper
9 3/4" x 13 3/4"

6 *Untitled (Stamped Shoes)*, c. 1959
Ink and ink wash on paper
23 3/4" x 17 7/8"

9 *Shoe of the Evening Beautiful Shoe (From the portfolio: A la Récherche du Shoe Perdu)*, 1955
Offset lithography, watercolor, and pen on paper
9 3/4" x 13 3/4"

10 *Untitled (High Heel)*, c. 1957
Gold leaf, ink, and stamped gold collage on paper
14 1/2" x 23"

13 *Dial M for Shoe (From the portfolio: A la Récherche du Shoe Perdu)*, 1955
Offset lithography, watercolor, and pen on paper
9 3/4" x 13 3/4"

14 *Untitled (Fantasy Shoes)*, c. 1956
Ink and ink wash on paper
22 5/8" x 28 5/8"

17 *You Can Lead a Shoe to Water But You Can't Make It Drink (From the portfolio: A la Récherche du Shoe Perdu)*, 1955
Offset lithography, watercolor, and pen on paper
9 3/4" x 13 3/4"

18 *Untitled (Six Shoes)*, c. 1953
Ink on paper
11" x 8 1/2"

21 *Shoe Fly Baby (From the portfolio: A la Récherche du Shoe Perdu)*, 1955
Offset lithography, watercolor, and pen on paper
9 3/4" x 13 3/4"

22 *Untitled (Man's Shoe)*, c. 1957
Gold leaf, silver leaf, and ink on paper
14 1/2" x 23"

25 *Diamond Dust Shoes*, 1980
Synthetic polymer paint, silkscreen ink, and diamond dust on canvas
90" x 70"

26 *Uncle Sam Wants Shoe (From the portfolio: A la Récherche du Shoe Perdu)*, 1955
Offset lithography, watercolor, and pen on paper
9 3/4" x 13 3/4"

29 *Ballet Slippers*, c. 1981–82
Synthetic polymer paint and silkscreen ink on canvas
32" x 20"

30 *Untitled (Feet)*, c. 1955–57
Ink on paper
14" x 16 7/8"

33 *Sunset and Evening Shoe (From the portfolio: A la Récherche du Shoe Perdu)*, 1955
Offset lithography, watercolor, and pen on paper
9 3/4" x 13 3/4"

34 *Untitled ("To All My Friends")*, c. 1957
Gold leaf and ink on paper
9" x 8"

37 *Beauty Is Shoe, Shoe Beauty (From the portfolio: A la Récherche du Shoe Perdu)*, 1955
Offset lithography, watercolor, and pen on paper
9 3/4" x 13 3/4"

38 *Any One for Shoes? (From the portfolio: A la Récherche du Shoe Perdu)*, 1955
Offset lithography, watercolor, and pen on paper
9 3/4" x 13 3/4"

41 *Untitled (High Heel)*, c. 1956
Gold leaf, ink wash, and stamped gold on paper
14 7/8" x 15 3/4"

42 *Shoe Fly Baby (From the portfolio: A la Récherche du Shoe Perdu)*, 1955
Offset lithography, watercolor, and pen on paper
9 3/4" x 13 3/4"

45 *Diamond Dust Shoes*, 1980
Synthetic polymer paint and silkscreen ink on canvas
90" x 70"

46 *Untitled (High Heel)*, c. 1956
Gold leaf, ink, and stamped gold on paper
11 1/4" x 15"

49 (top) *See a Shoe and Pick It Up and All Day Long You'll Have Good Luck (From the portfolio: A la Récherche du Shoe Perdu)*, 1955
Offset lithography, watercolor, and pen on paper
9 3/4" x 13 3/4"

49 (bottom) *See a Shoe and Pick It Up (From the portfolio: A la Récherche du Shoe Perdu)*, 1955
Offset lithography, watercolor, and pen on paper
9 3/4" x 13 3/4"

50 *I Dream of Jeannie With the Light Brown Shoe (From the portfolio: A la Récherche du Shoe Perdu)*, 1955
Offset lithography, watercolor, and pen on paper
9 3/4" x 13 3/4"

53 *My Shoe Is Your Shoe (From the portfolio: A la Récherche du Shoe Perdu)*, 1955
Offset lithography, watercolor, and pen on paper
9 3/4" x 13 3/4"

54 *Untitled (Paratrooper Boots)*, c. 1984–85
Synthetic polymer paint on paper
30 1/8" x 40"

57 *Untitled (Shoe and Leg)*, c. 1956
Ink and ink wash on paper
19 1/2" x 13 3/8"

58 *Untitled (Legs and High Heels)*, c. 1957
Gold leaf, ink, and stamped gold collage on paper
24 5/8" x 19 1/4"

61 *In Her Sweet Little Alice Blue Shoes (From the portfolio: A la Récherche du Shoe Perdu)*, 1955
Offset lithography, watercolor, and pen on paper
9 3/4" x 13 3/4"

62 *When I'm Calling Shoe (From the portfolio: A la Récherche du Shoe Perdu)*, 1955
Offset lithography, watercolor, and pen on paper
9 3/4" x 13 3/4"

65 *To Shoe or Not To Shoe (From the portfolio: A la Récherche du Shoe Perdu)*, 1955
Offset lithography, watercolor, and pen on paper
9 3/4" x 13 3/4"

66 *Diamond Dust Shoes*, 1980
Synthetic polymer paint, silkscreen ink, and diamond dust on canvas
90" x 70"

69 *Dial M for Shoe (From the portfolio: A la Récherche du Shoe Perdu)*, 1955
Offset lithography, watercolor, and pen on paper
9 3/4" x 13 3/4"

70 *Untitled (High Heel)*, c. 1956
Gold leaf, ink, and stamped gold collage on paper
13 1/8" x 13 1/4"

73 *Shoe Bright, Shoe Light, First Shoe I've Seen Tonight (From the portfolio: A la Récherche du Shoe Perdu)*, 1955
Offset lithography, watercolor, and pen on paper
9 3/4" x 13 3/4"

74 *Untitled (Urn with Two Legs)*, c. 1958
Ink on paper
21 1/2" x 14 1/4"